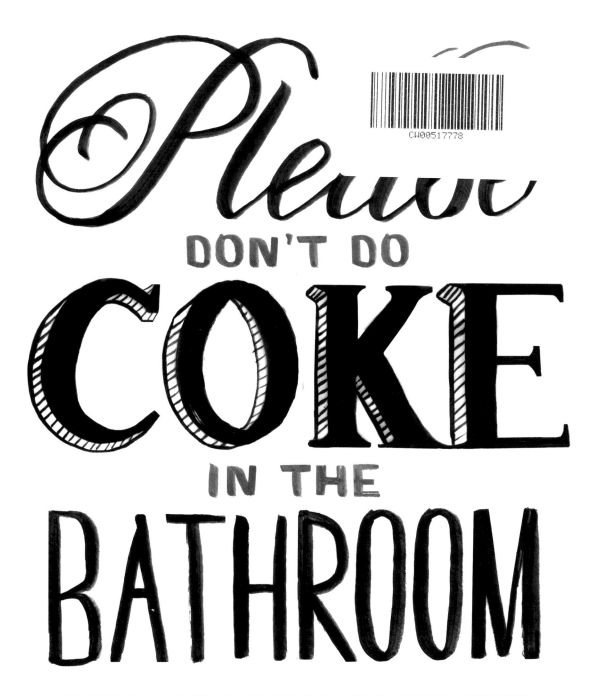

Please DON'T DO COKE IN THE BATHROOM

IRREVERENT HAND LETTERING FOR EVERY F*CKING OCCASION

WRITTEN & ILLUSTRATED BY
Sami Christianson

Race Point
PUBLISHING

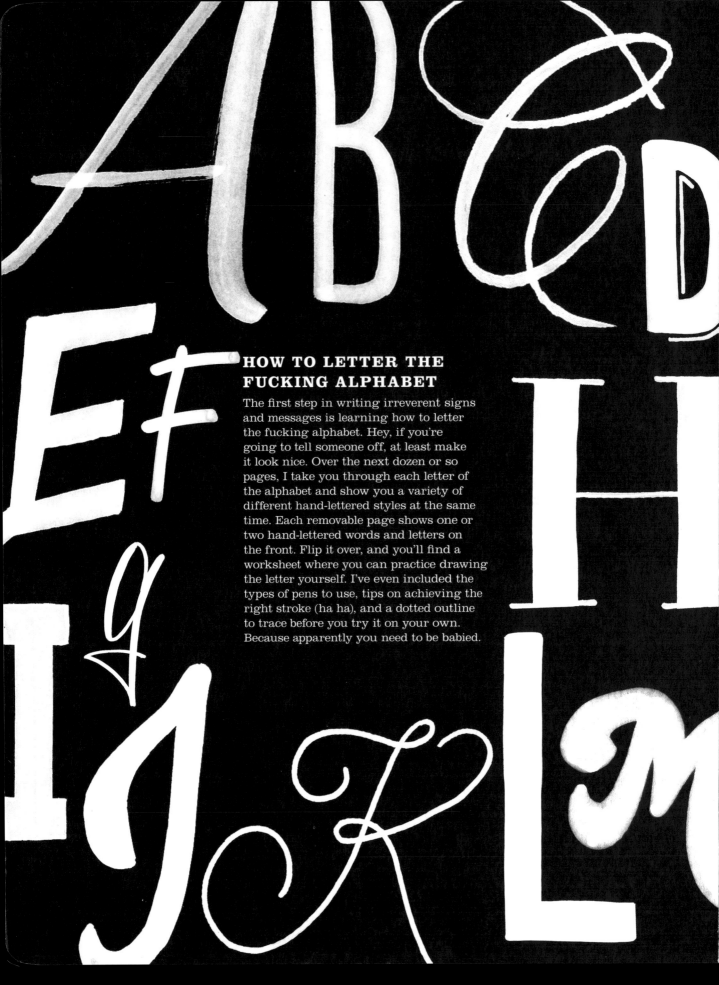

HOW TO LETTER THE FUCKING ALPHABET

The first step in writing irreverent signs
and messages is learning how to letter
the fucking alphabet. Hey, if you're
going to tell someone off, at least make
it look nice. Over the next dozen or so
pages, I take you through each letter of
the alphabet and show you a variety of
different hand-lettered styles at the same
time. Each removable page shows one or
two hand-lettered words and letters on
the front. Flip it over, and you'll find a
worksheet where you can practice drawing
the letter yourself. I've even included the
types of pens to use, tips on achieving the
right stroke (ha ha), and a dotted outline
to trace before you try it on your own.
Because apparently you need to be babied.

A is for Asshole

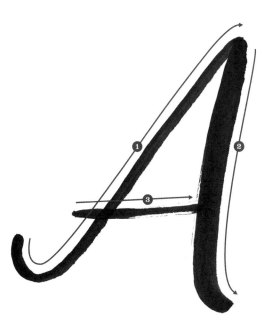

LOOSE BRUSH LETTERING
Pen used: Pentel Brush Pen

With a Pentel Brush Pen and India ink
(a small paintbrush works if you don't have
a Pentel Brush Pen), use different levels of
pressure to create different stroke widths.
Make sure you hold the pen at a 35-degree
angle at all times, and are picking the pen
off the paper after each stroke.

Take a crack at it, **IT'S FUCKING THERAPEUTIC:**

B IS FOR

BITCH

Try it in a sentence:
"Bitch, please, no one believes those are real!"

C is for

Clusterfuck

When to use:
Best to use when describing a disastrous situation where things have gone horribly wrong very quickly... usually because of an idiot.

SHARPIE SANS SERIF
Pen used: Fine Point Sharpie

This simple style has so much character that it's hard to believe it was made with a Sharpie. Always keep consistent pressure when drawing in this style. The Sharpie gives you the flexibility of creating regular, condensed, or wide letters that will still feel consistent because the marker has a round nib.

Don't be a chicken shit,
TRY IT YOURSELF:

CALLIGRAPHIC SCRIPT
Pen used: Speedball Dip Pen
(any nib size)

The most traditional form of lettering is also one of the toughest. Your pen should always be held at a 35-degree angle to the paper. Downstrokes should have heavy pressure, and upstrokes should have light pressure. It's important in traditional calligraphy that you pick up your pen after each stroke to dip it in the ink.

Stop being a fucking wimp,
GIVE IT A SHOT:

D
IS FOR
DOUCHEBAG

Try it in a sentence:
"He looks like the kind
of douchebag who would
funnel beers at brunch."

CONDENSED SANS SERIF
Pen used: Felt-Tip Marker

You can achieve this style with almost any regular felt-tip pen or Sharpie. Just make sure you have a super-thick point for the letters and a thin point for the drop shadows.

Take a crack at it, **IT'S FUCKING THERAPEUTIC**:

E is for Epic Fail

Try it in a sentence:
"Well, that condom was an epic fail."

F is for Fuck Face

When to use:
One of the few insults that works for people you hate, "Get outta my way, Fuck Face!" or people you like, "Hey, Fuck Face, are we going out tonight?"

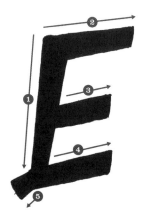

BLOCK ITALICS
Pen used: Pilot Parallel Pen 3.8 mm

This pen is great for drawing geometric letters. I usually choose a pen width that makes the thinnest part of the stroke, and then I thicken areas of each stroke with a fineliner pen to give it a little extra character.

Stop being a fucking wimp,
GIVE IT A SHOT:

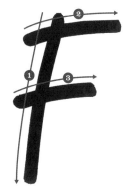

LOOSE HANDWRITING
Pen used: Faber-Castell PITT Artist Pen 2.5 mm

Sometimes you don't need anything fancy to create letters with character. All you need is a felt-tip pen with a medium nib. Write in cursive and you will end up with a friendly handwritten style.

Don't be a chicken shit,
TRY IT YOURSELF:

When to use:
Best used when dealing with close
talkers, walkers, and stalkers.

G is for
G get the Hell
Away from Me

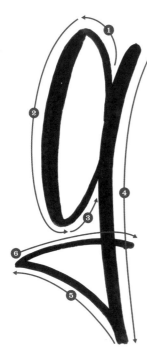

EDGY HANDWRITING
Pen used: Faber-Castell India Ink PITT Artist Pen Big Brush

This style must be done with a pen with a flat edge. Sometimes in lettering all it takes to change the style is to modify the speed at which you write. This style benefits from a faster stroke. Just remember to pick up the pen after each stroke.

Take a crack at it, **IT'S FUCKING THERAPEUTIC**:

H
IS FOR
HELL
BEAST

When to use:
Best used when describing
someone who has emerged
from the very depths of hell
to make your existence both
shitty and miserable.
You know the type.

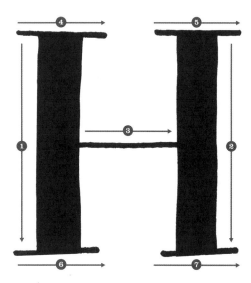

HAND-DRAWN SERIF
Pen used: Pilot Parallel Pen 6.0 mm

This is a fairly simple style. All it takes is using the two different edges of the pen to create different widths. For the downstrokes, use the flat edge of the nib. For the horizontal strokes, use only the tip of the pen to create an extremely thin line. The wonkier the better.

Take a crack at it, IT'S FUCKING THERAPEUTIC:

When to use:

Best used when dealing with broad-based stupidity that is likely the result of an inflated ego combined with unfortunate DNA.

I IS FOR IMBECILE

I is for Jackass

Try it in a sentence:

"It's called a turn signal, jackass. Try using it."

BOLD SLAB SERIF
Pen used: Pilot Parallel Pen 6.0 mm

All it takes to do this style is using the thick side of the parallel pen. Doing this keeps all the widths consistent. You can always go in afterward and round the inner and outer corners with a fineliner pen or add any sort of detail.

THIN RETRO SCRIPT
Pen used: Faber-Castell PITT Soft Brush Pen

This is a fun style. You can use almost any brush pen to create this style. Try to keep the weight uniform throughout, except at the beginning and end of each stroke. The ends of each stroke should be made a bit thicker to give the letter a more retro feel.

Try it in a sentence:
"Your knickers seem to have fallen around your ankles."

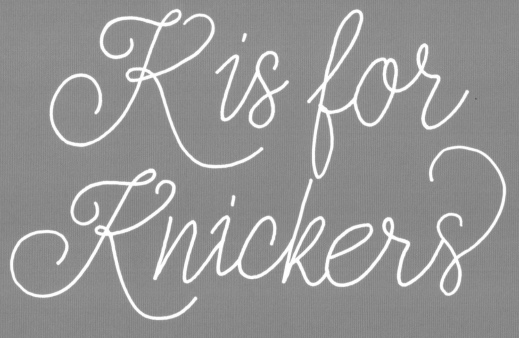

K is for Knickers

is for LOSER

When to use:
Best used to describe someone who sucks at everything relevant.

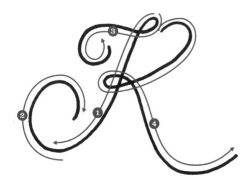

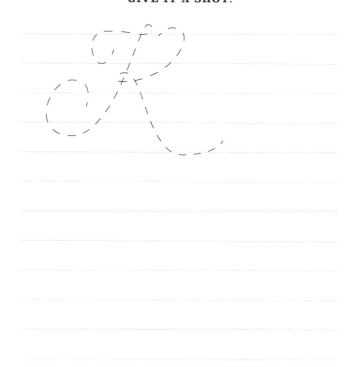

FINELINER SCRIPT
Pen used: Faber-Castell India Ink PITT Artist Pen XS

This is a thin, continous, extra flourishy script that feels feminine and elegant. Stick with a pen that is fairly thin. Flourishes are difficult, but the trick is to draw them in one flawless motion. Don't stop midway through a flourish or they will start to look jagged.

Don't be a chicken shit,
TRY IT YOURSELF:

BOLD SANS SERIF
Pen used: Chisel Tip Sharpie

The look of this style can change depending on how thick the pen is. To get something this bold, the bigger the point, the better. Each stroke should be done as a continous line.

Use it as a noun and an adjective in
the same insult for effect:
"Get your motherfucking face out
of my motherfucking house
motherfucker."

M is for Motherfucker

N is for Nards

When to use:
Best used when referring to a sweet-smelling
Himalayan plant. Or testicles.

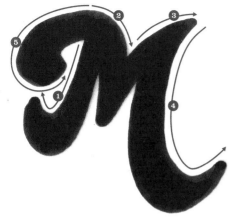

RETRO SCRIPT
Pen used: Faber-Castell India Ink PITT Artist Pen Big Brush & India Ink PITT Artist Pen XS

This is one of my favorite lettering styles to draw. You can have a lot of fun with the line weights. The crazier you go, the better it ends up looking. You want to start by using the brush pen to achieve the different thick and thin lines. Then finesse the tips and curves with a fineliner pen.

Don't be a chicken shit,
TRY IT YOURSELF:

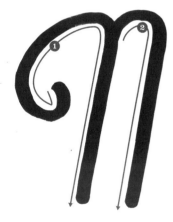

CONDENSED ABSTRACT
Pen used: Pilot Parallel Pen 3.8 mm

This style shows a different way of using a parallel pen. The trick here is to make sure each stroke is at the exact same angle and the negative and positive spaces are all equal. Only use the flat part of the nib for this style to ensure every stroke is the same width.

Stop being a fucking wimp,
GIVE IT A SHOT:

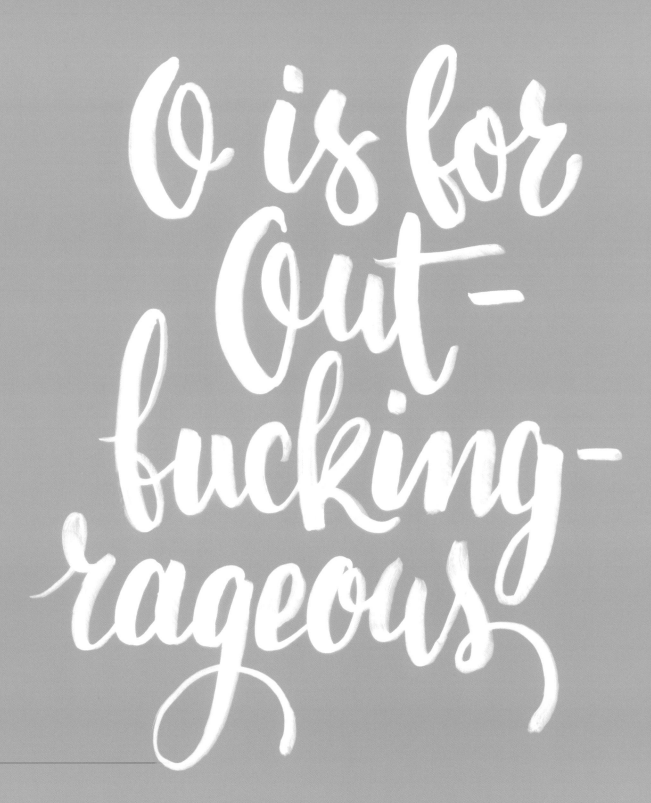

Try it in a sentence:
"His chewing is so loud it's outfuckingrageous."

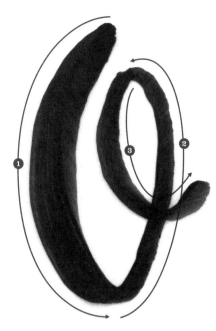

LOOSE BRUSH LETTERING
Pen used: Pentel Brush Pen

This style works best when you really accentuate the thick and thin lines. You need a lot of contrast in the line weights. You don't want a gradual transition, but more of a blunt one. This is achieved by picking up the brush before you start the upstroke.

Take a crack at it, **IT'S FUCKING THERAPEUTIC:**

Try it in a sentence:
"That prick better pick up the tab this time."

P is for PRICK

Try it in a sentence:
"I didn't think that quickie
was ever going to end!"

Q is for Quichie

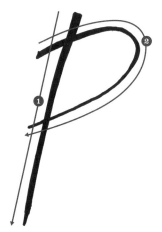

STYLIZED ITALICS
Pen used: Faber-Castell India Ink PITT Artist Pen XS

You can do whatever you want with this style. Start with a very thin stroke and add on thick strokes as you please. You can give the word you are drawing a lot of character and make it reflect what it actually says, like I have done with this particular letter.

Don't be a chicken shit,
TRY IT YOURSELF:

BRUSH SCRIPT
Pen used: Pentel Brush Pen

This is a loose, flowing style that really benefits from the texture of the ink. Don't be afraid to let a little dry brushing show through. The downstrokes should always be thicker. Make sure to lift your pen on the upstrokes to create the thin lines.

R is for Resting Bitch Face

Try it in a sentence:
"Nah, she ain't mad. She just has Resting Bitch Face."

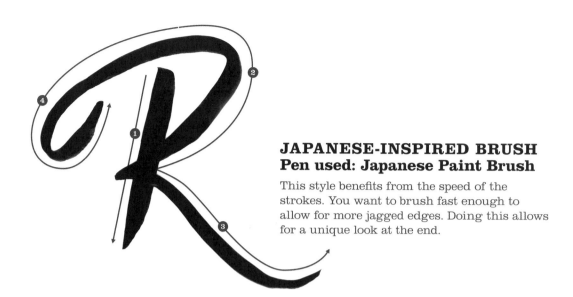

JAPANESE-INSPIRED BRUSH
Pen used: Japanese Paint Brush

This style benefits from the speed of the strokes. You want to brush fast enough to allow for more jagged edges. Doing this allows for a unique look at the end.

Take a crack at it, **IT'S FUCKING THERAPEUTIC**:

S is for Shithead

When to use:
Ideal for hurling an insult
at someone and then
denying you ever said it.

T IS FOR TWAT DID YOU SAY?

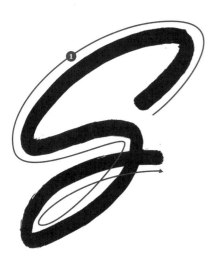

FELT-TIP SCRIPT
Pen used: Faber-Castell
PITT Bullet Nib Pen

This style should be drawn using one continous line per letter. The faster you can write, the better. It will give your text a graffiti feel.

WONKY SANS SERIF
Pen used: Pilot Parallel
Pen 3.8 mm

This style uses the two different edges of the pen to create different widths. For the downstrokes, use the flat edge of the nib. For the horizontal strokes, use only the tip of the pen to create an extremely thin line. It's okay if the lines aren't perfectly straight; it gives it extra character.

Stop being a fucking wimp,
GIVE IT A SHOT:

Try it in a sentence:
"Damn, these filters make you look
unfuckingbelievable."

U is for
Unfuckingbelievable

V is for Vomit

Try it in a sentence:
"Going into work makes me want to vomit,
so this sick day is for realz."

ONE WIDTH SERIF
Pen used: Sharpie Fine Point

This is a super-simple style to draw. Make sure your letters are evenly spaced and choose a pen width that isn't too wide. You can add the serifs at the end to give it extra character.

ROUNDED SCRIPT
Pen used: Faber-Castell India Ink PITT Artist Pen

The trick to this style is to not create any hard corners or edges. So, when drawing, always make sure you round the ends of each stroke. I usually stick to sentence case for this style. It gives the overall words a friendlier feel.

W

— IS FOR —

WHAT

THE FUCK?

**Try it in
a sentence:**
"What the fuck is
your problem today/
right now/always?"

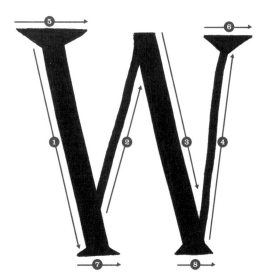

DECORATIVE SERIF
Pen used: Pilot Parallel Pen 3.8 mm & Faber-Castell India Ink PITT Artist Pen XS

I usually begin drawing this style with a pencil. Doing this allows more flexibility in stylizing the serifs. Use a pen with a thick width for all the downstrokes and a pen with a thinner width for the upstrokes. Then refine and customize the serifs afterward.

Take a crack at it, IT'S FUCKING THERAPEUTIC:

X is for an anxiety-reducing drug that we cannot list here due to trademark restrictions.

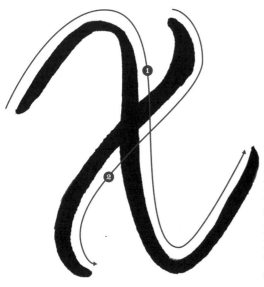

LOOSE BRUSH LETTERING
Pen used: Pentel Brush Pen

This style works best by exaggerating the length of the strokes that connect each letter. The more you can overexaggerate, the better. At first glance, it should almost appear as an abstract line.

Take a crack at it, **IT'S FUCKING THERAPEUTIC**:

Try it in a personal letter:
Dear Nickelback,
You suck.
From,
The World

Y is for You Suck

Try it in a sentence:
"Would you kindly zip it back up, please?"

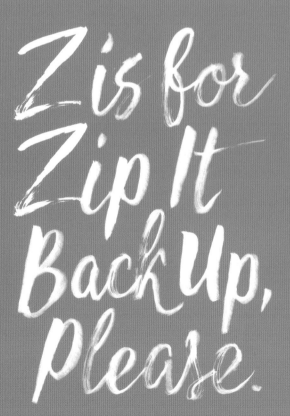

SLAB SERIF SCRIPT
Pen used: Faber-Castell India Ink Pen PITT Artist Pen

I would say that this style is bit of a made-up hybrid style by moi. Make sure you are using a rounded nib pen so all the widths stay consistent. Experiment with what letters can connect and what should stand alone. Each saying you write will look different.

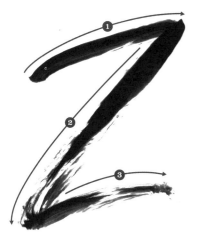

DRY BRUSH SCRIPT
Pen used: Pentel Brush Pen

I love this style. It can be done with essentially any type of script. The key, though, is after you dip your brush in ink, make sure you dab about half the ink off. Doing this will give you that really nice texture you see in the example.

Stop being a fucking wimp,
GIVE IT A SHOT:

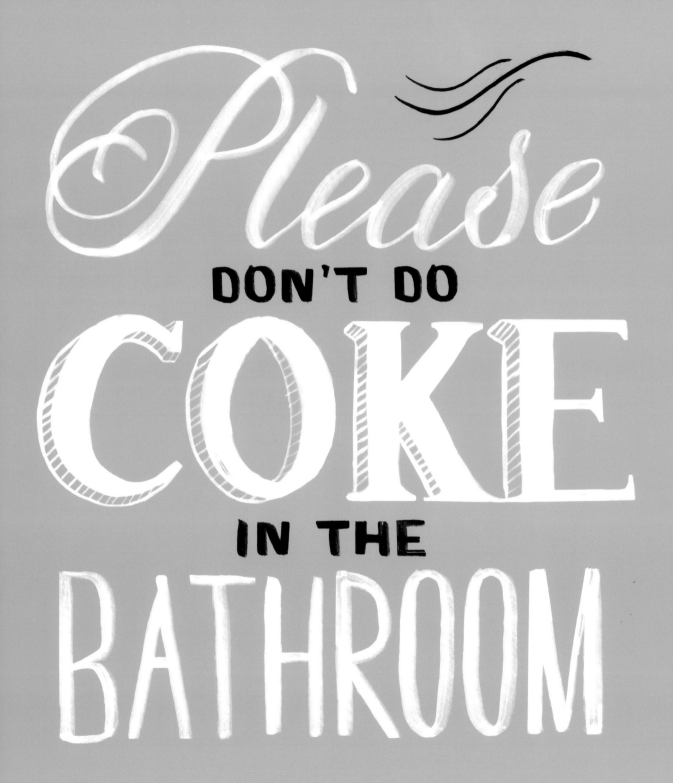

Monday
is a
Dick

HAPPY FUCKING NEW YEAR

Your Spirit Animal is an Asshole

PLEASE
WASH
YOUR
HANDS
(THEY SMELL LIKE SHIT)

Fuck You, Kale

— THE —

MANAGEMENT REQUESTS YOU GET YOUR SHIT TOGETHER

I Miss You, Asshole

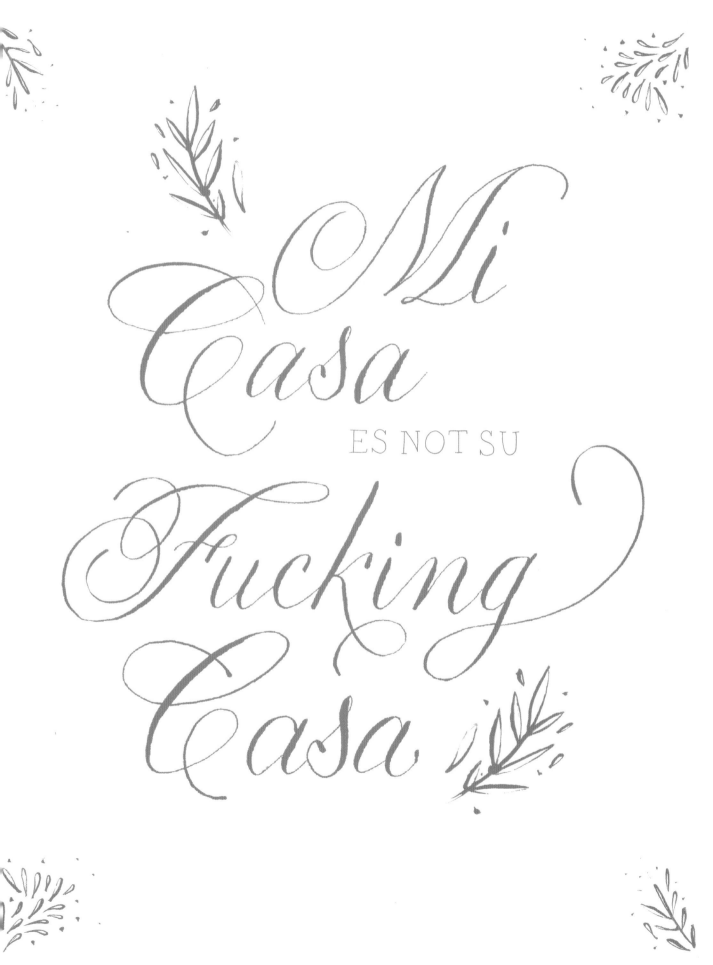

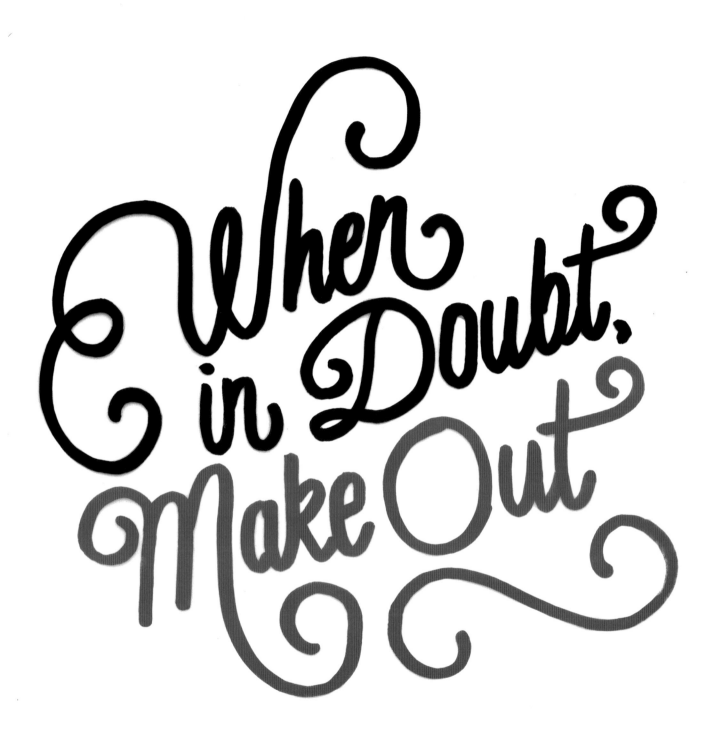

Seventy
Minus
One =
Fun